NATURE

MAN...
WHO TRUSTED GOD WAS LOVE INDEED
AND LOVE CREATION'S FINAL LAW—
THO' NATURE, RED IN TOOTH AND CLAW
WITH RAVINE, SHRIEKED AGAINST HIS CREED.

Alfred, Lord Tennyson

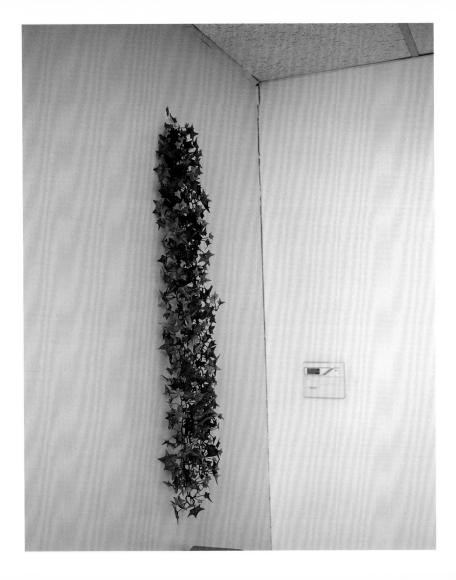

PHOTOGRAPHS BY

LIZ COCKRUM

JENNIFER LITTERER

JESSICA BRUAH

THOMAS TUKIENDORF

GIDEON BARNETT

SUZY POLING

COLLEEN PLUMB

NATURE

Columbia
COLLEGE CHICAGO

LIZ COCKRUM

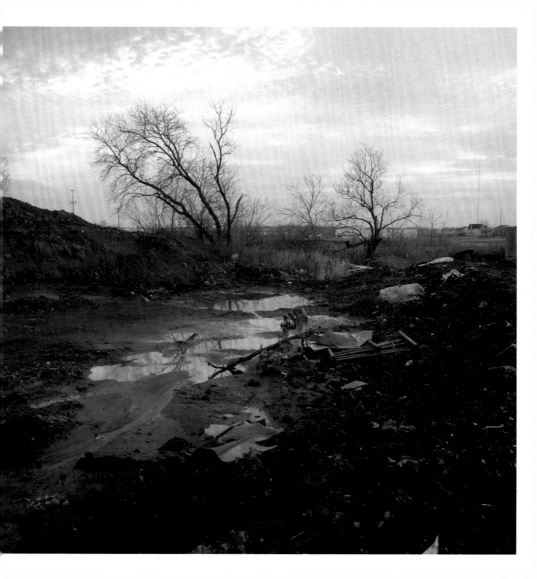

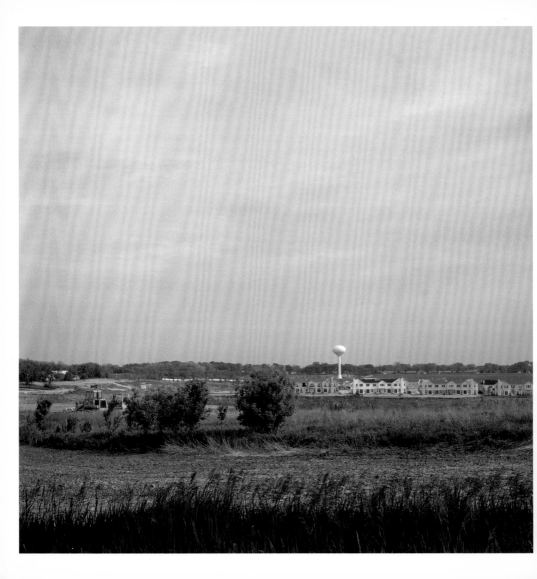

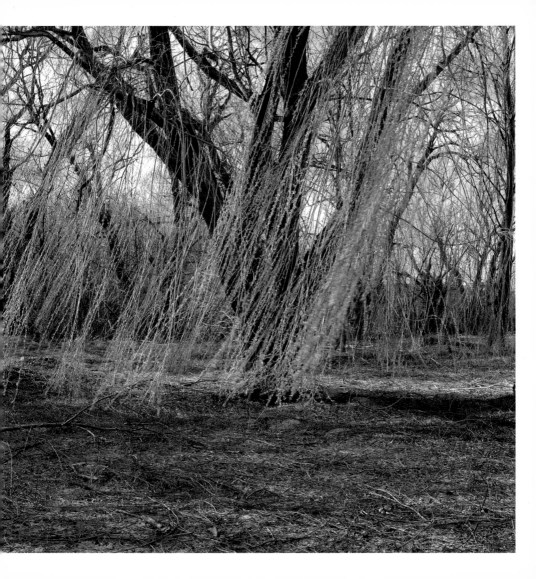

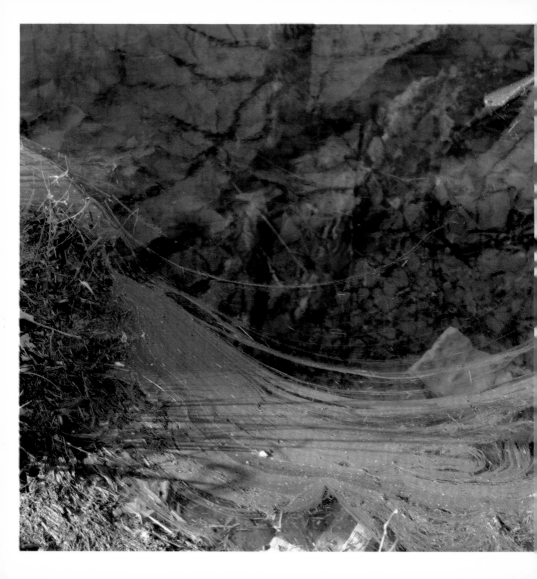

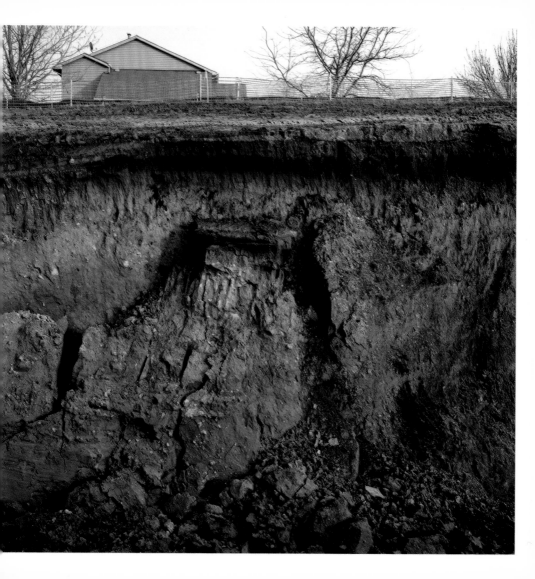

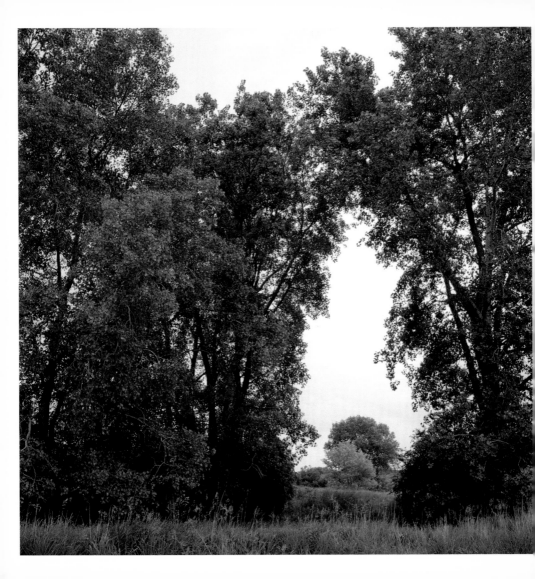

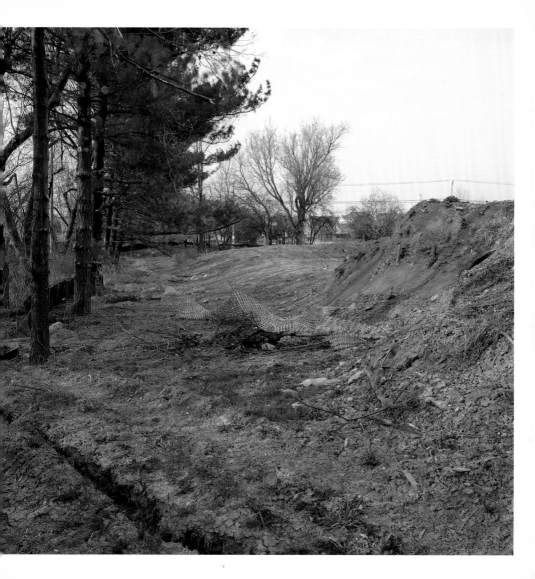

JENNIFER LITTERER

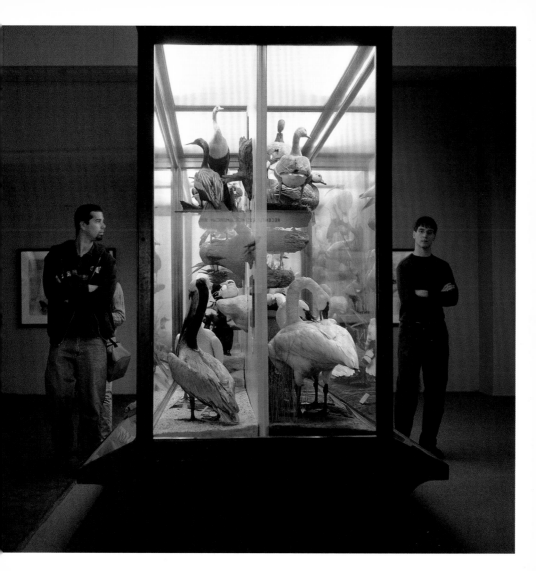

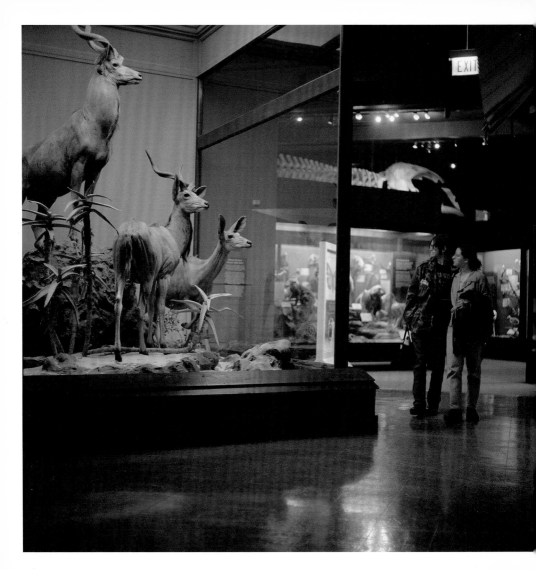

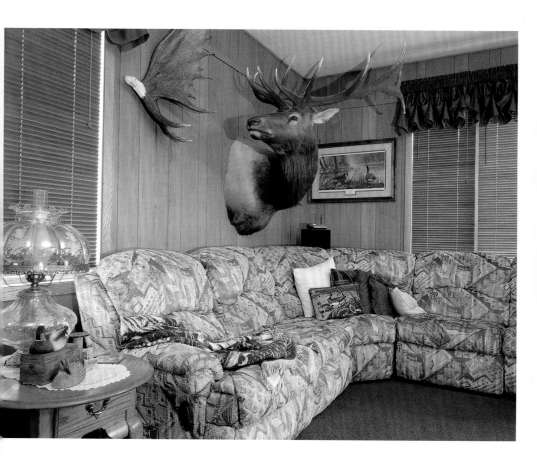

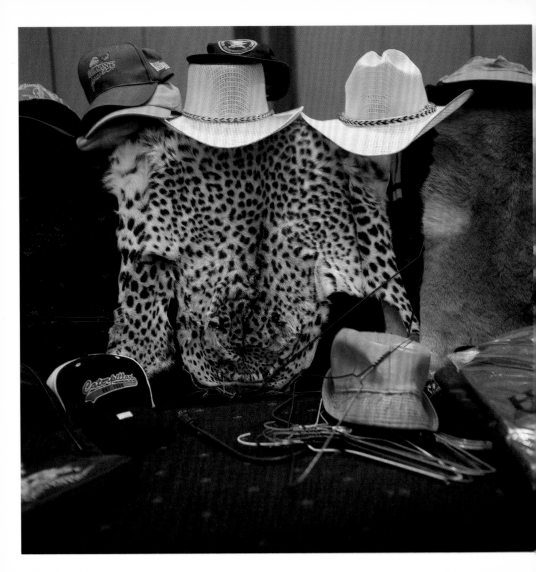

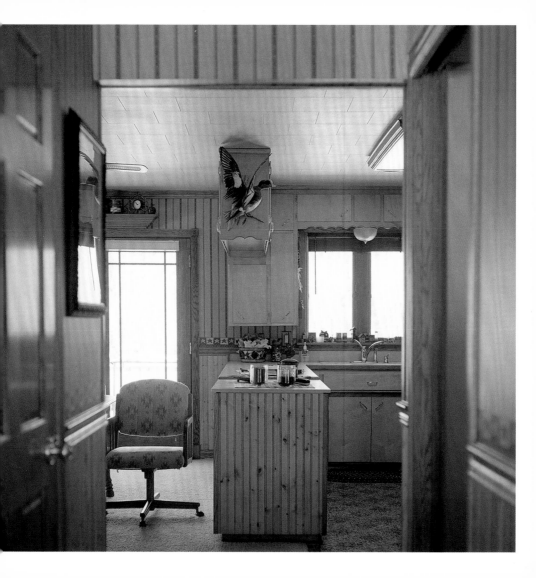

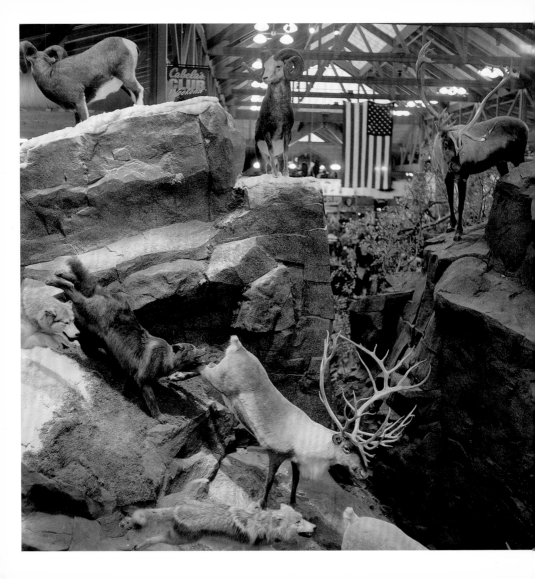

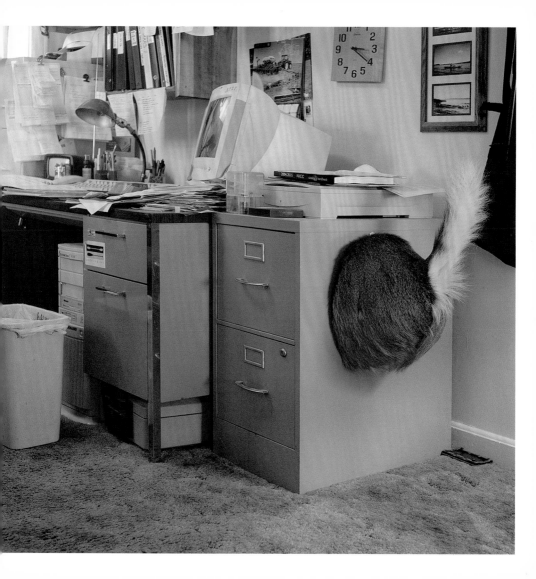

JESSICA BRUAH

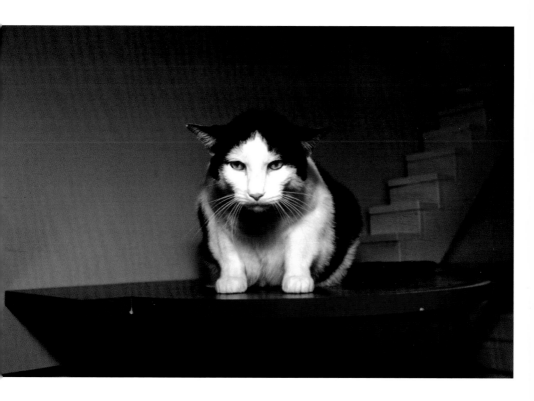

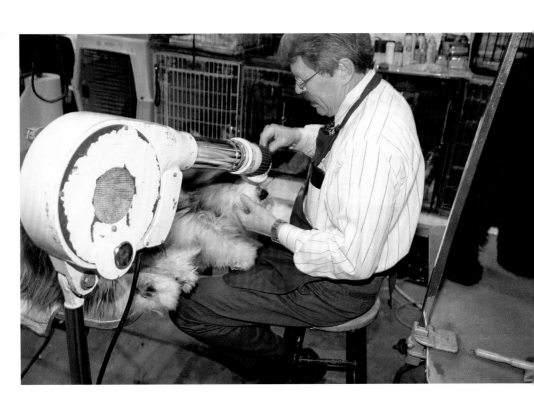

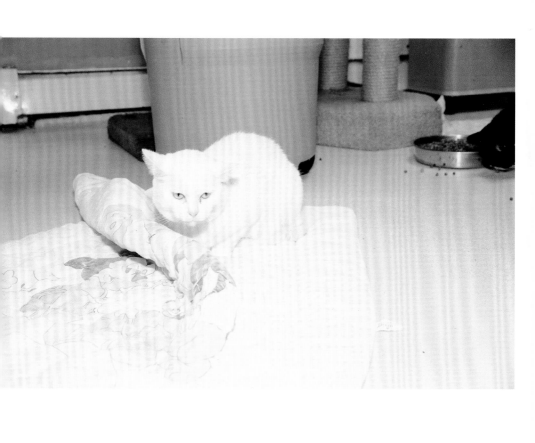

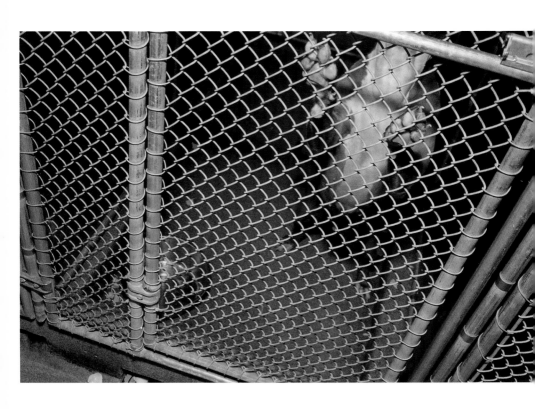

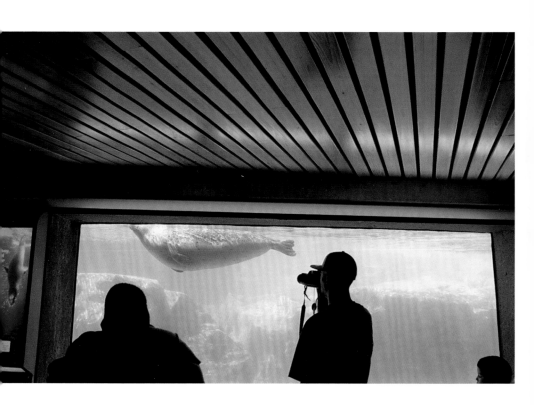

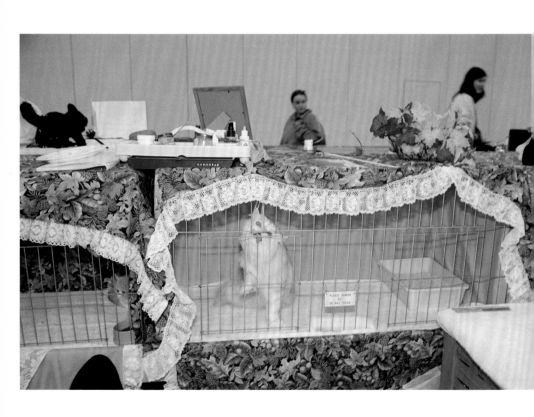

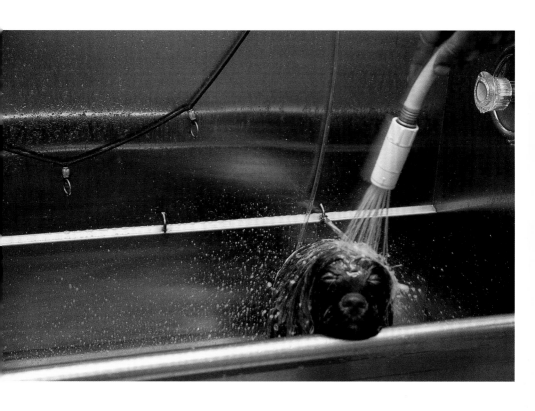

THOMAS TUKIENDORF

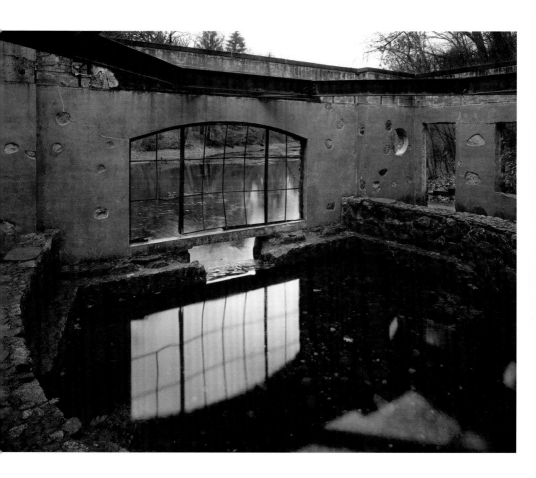

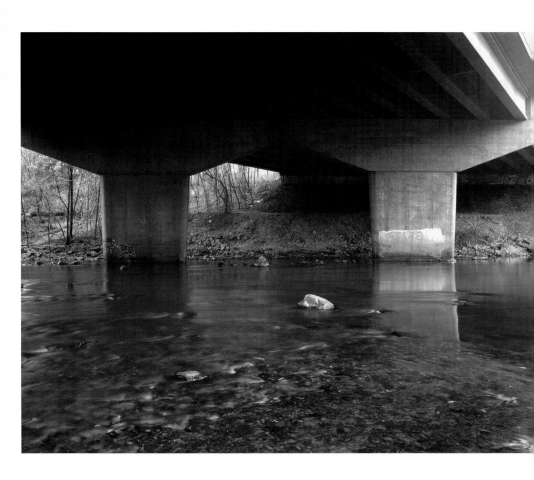

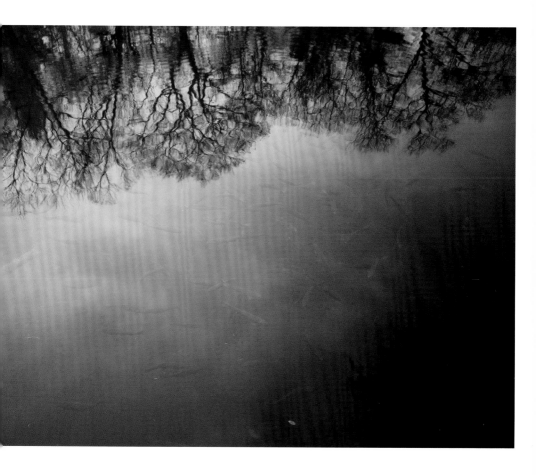

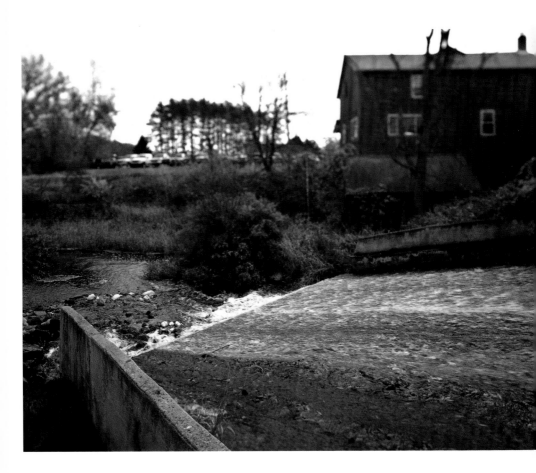

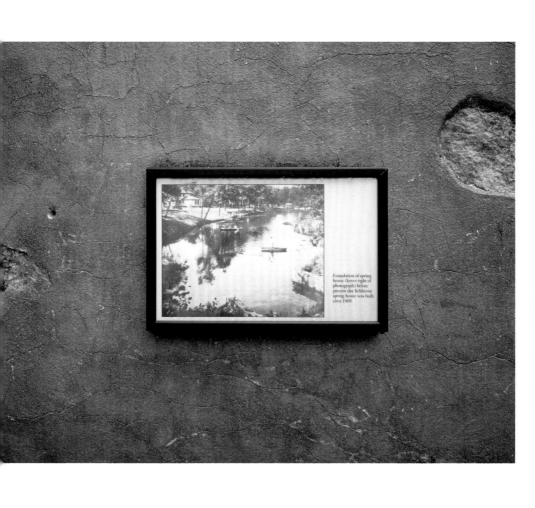

Foundation of spring house (lower right of photograph) before present day fieldstone spring house was built, circa 1900.

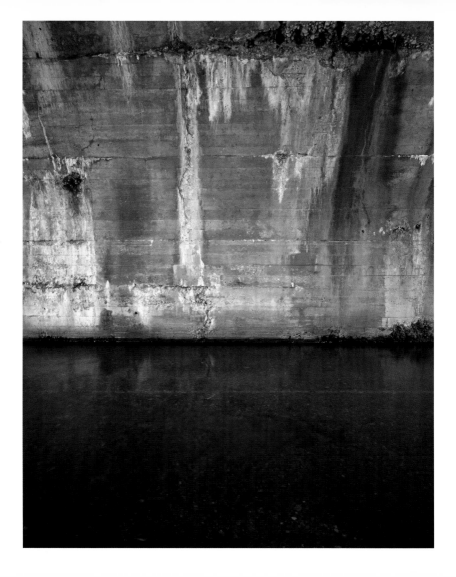

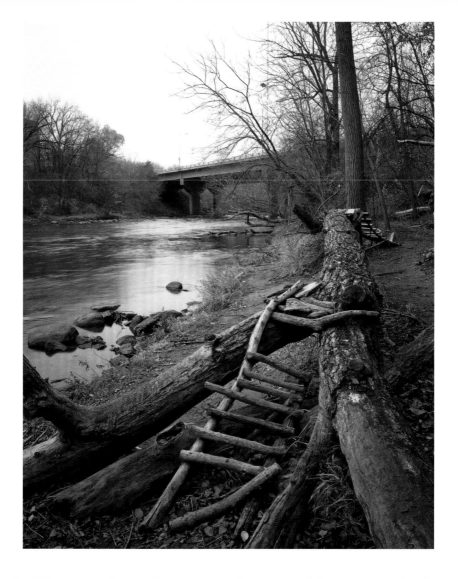

GIDEON BARNETT

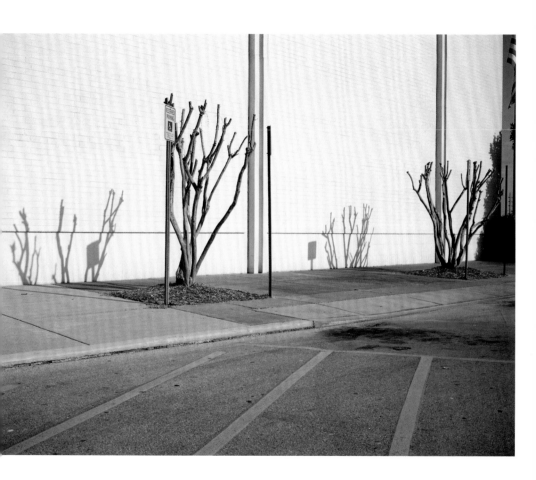

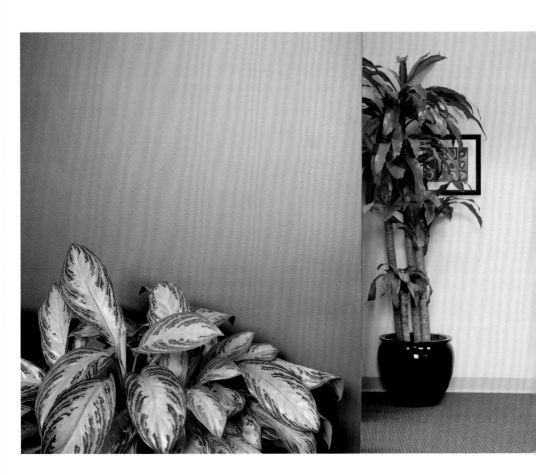

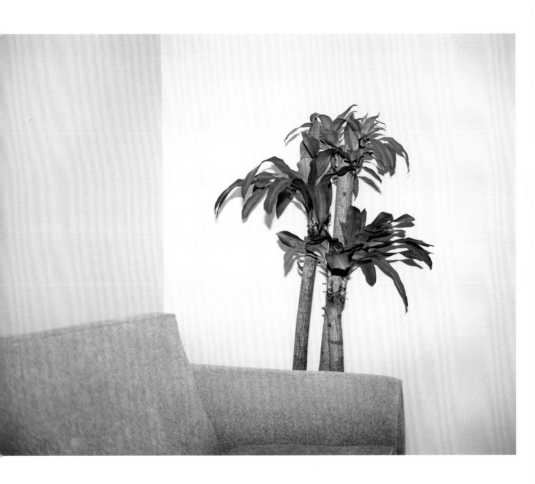

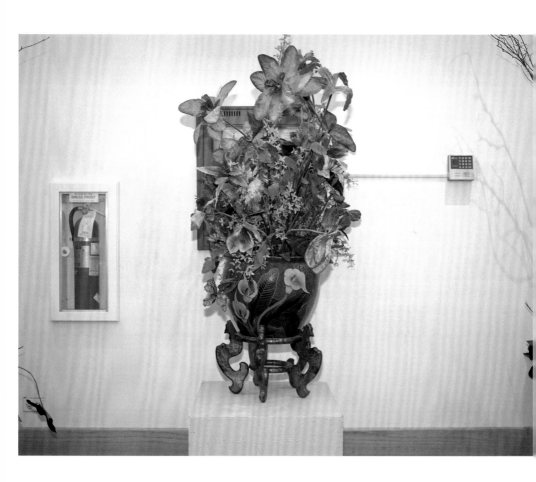

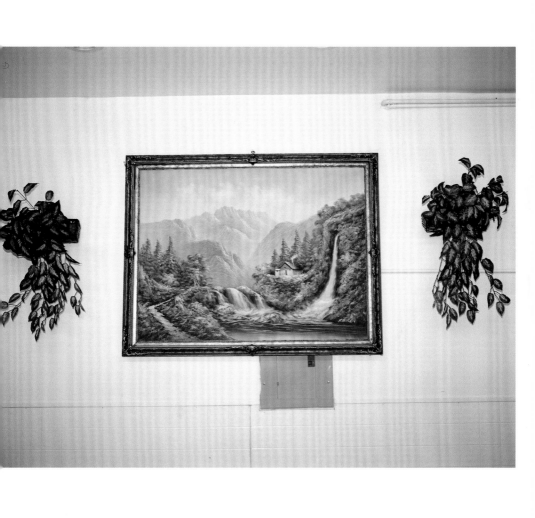

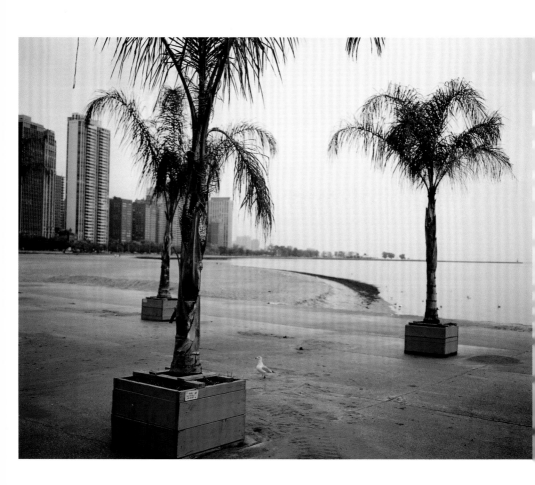

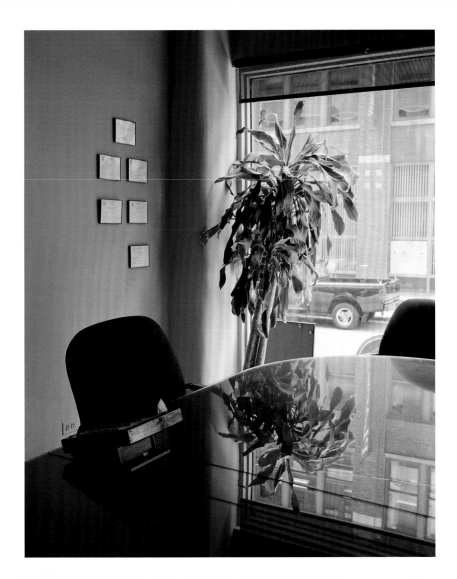

SUZY POLING

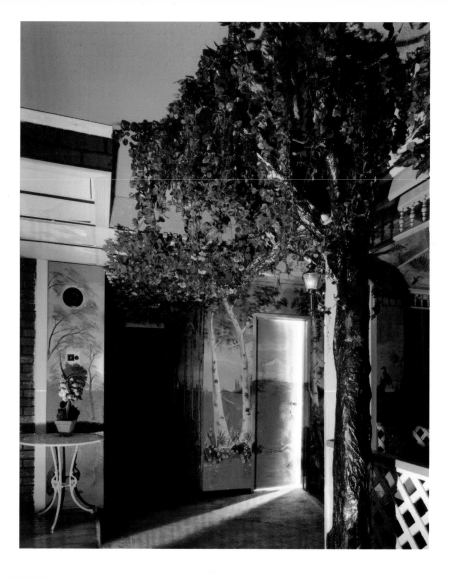

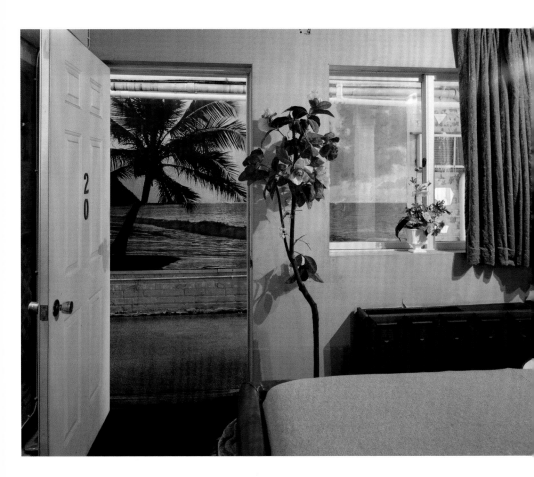

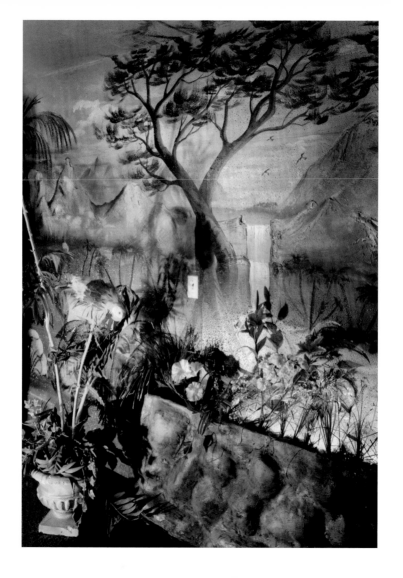

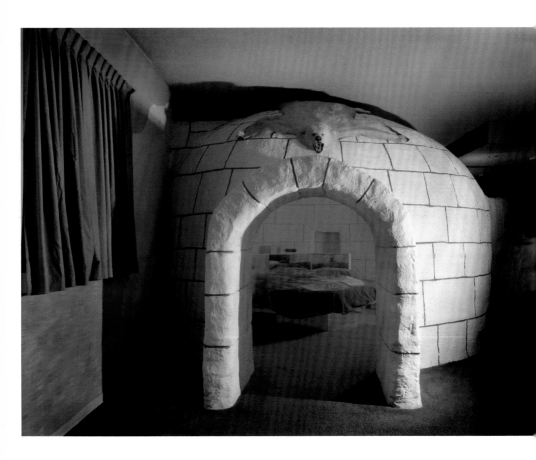

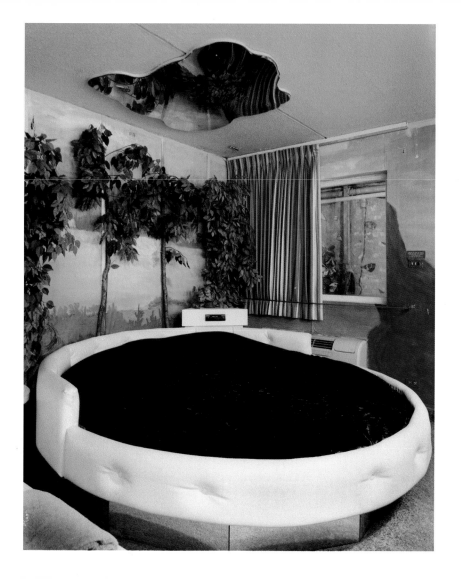

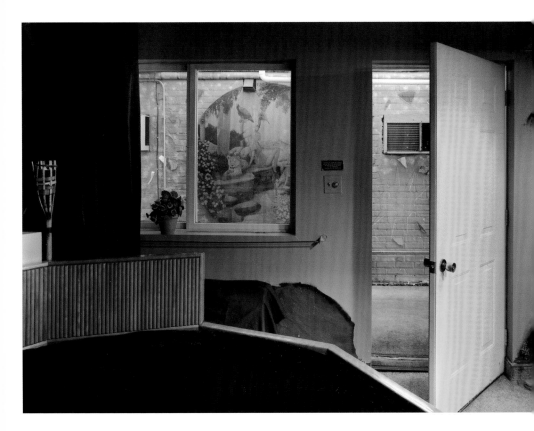

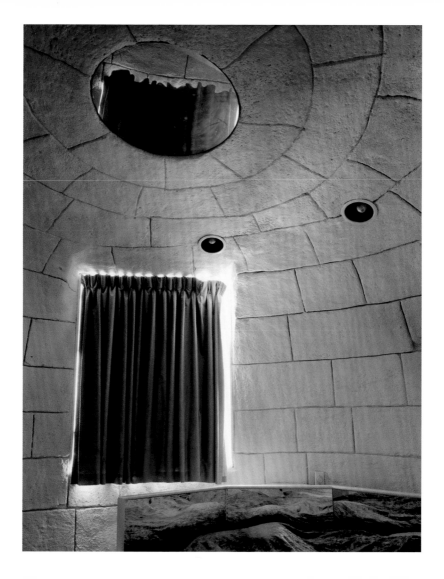

COLLEEN PLUMB

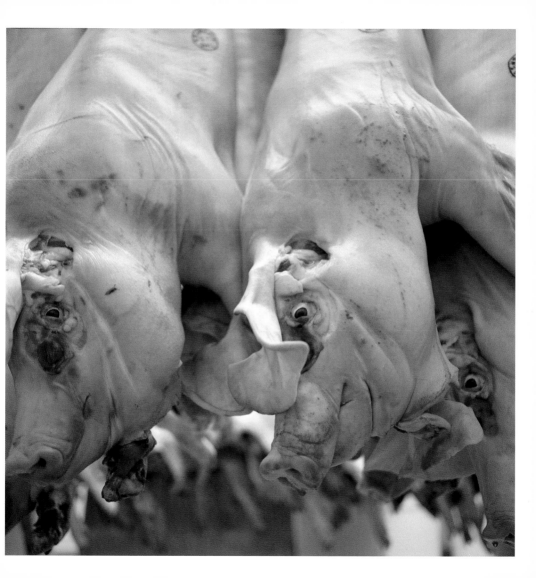

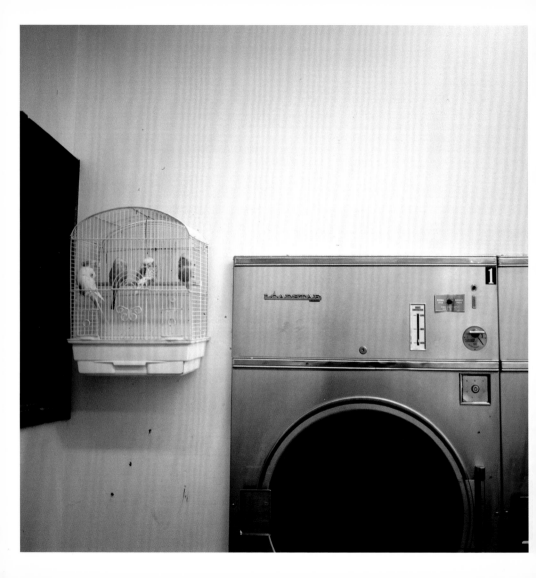

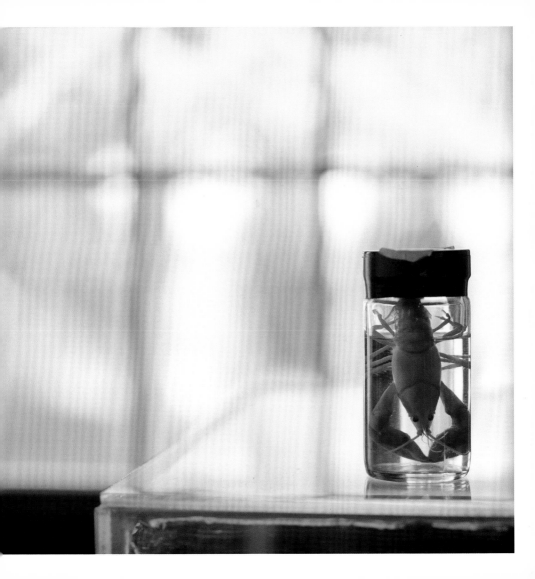

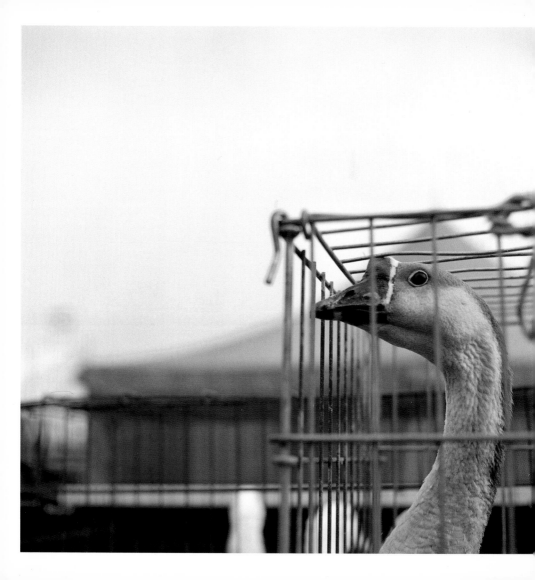

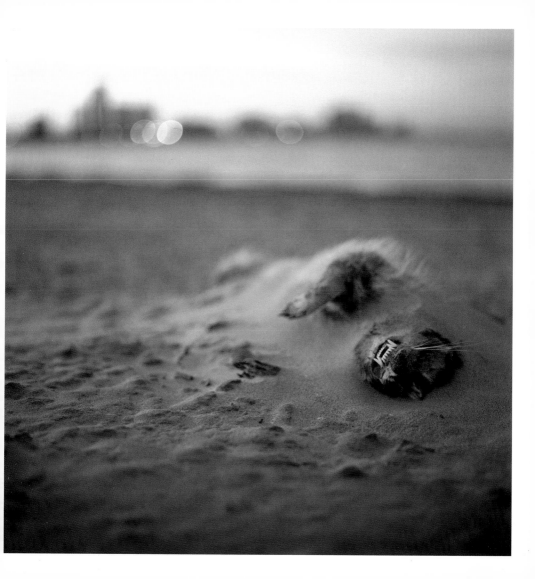

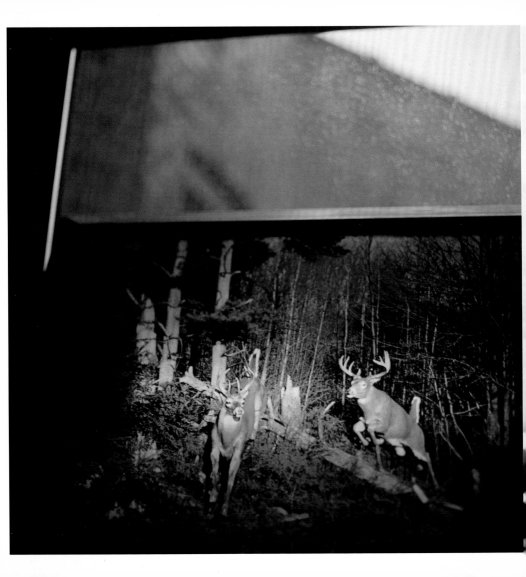

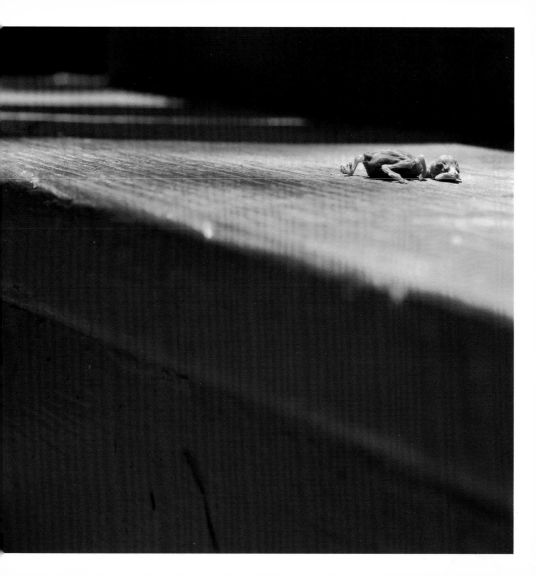

GIDEON BARNETT (b. 1982, Jasper, Tenn.) received a BFA in photography from Columbia College Chicago, where he was selected for the Hokin Honors Exhibition. His work, *My Artist's Book*, was shown at the Hunter Museum of American Art in Chattanooga, Tennessee; other exhibitions include the In-Transit Gallery and the Studios at 600 South Wabash in Chicago.

Flora is a series of photographs describing potted plants and indoor landscaping. I am interested in the environments people create, and how those spaces reveal their priorities, perhaps more than they realize. I am fascinated with the resiliency of the tradition of using nature as decoration and the ways in which that tradition is often perverted.

30" x 40" archival digital prints www.gideonbarnett.com

JESSICA BRUAH (b. 1981, Rockford, Ill.) received a BFA in photography from Columbia College Chicago. She was awarded the Jack Jaffe Scholarship and the Albert P. Weisman Memorial Scholarship. Her exhibitions include Around the Coyote Winter Festival in Chicago, the Orleans Street Gallery in St. Charles, Illinois, and the Photo-eye online gallery.

Animal Control examines the relationships people have with animals, both domesticated and wild. Human manipulation of the animal kingdom often translates into bizarre and fantasy-filled notions of nature. Our treatment of animals varies dramatically: we revere the loyal family dog, placing it on diets and pampering it at the salon; we closely observe wild, exotic beasts at the zoo, albeit separated by a cage or ditch. On the other hand, we easily ignore the excessive number of unwanted pets in shelters, many neglected or abused by their previous owners. I visited many places in order to document this complex animal-human interaction. The majority of images were taken at dog shows, zoos, animal shelters, and pet salons.
11" x 14" chromogenic prints www.jessicabruah.com

LIZ COCKRUM (b. 1983, Winfield, Ill.) earned a BFA in photography from Columbia College Chicago. She was awarded the Jack Jaffe Scholarship, Albert P. Weisman Memorial Scholarships, and the John Mulvany Scholarship. Her work has been exhibited widely in Chicago, including group shows at the Glass Curtain Gallery, Hokin Annex, and Flatfile Gallery.

My photographs document the transformation of the Chicago suburban landscape. By photographing the remaining natural areas before, during, and after development, I hope to create an awareness of the ways in which we compromise the land. My aim is to challenge the viewer to consider whether it is worth the eradication of our natural environment to make room for an abundance of cookie-cutter homes and strip malls.
16" x 20" chromogenic prints www.lizcockrum.com

JENNIFER LITTERER (b. 1980, Dougherty, Iowa) holds a BA from the University of Iowa and is an MFA candidate in photography at Columbia College Chicago. Her photographs have been exhibited in Iowa at MacNider Art Museum in Mason City, Franklin County Fair in Hampton, and Dougherty Community Center in Dougherty, and were published in *A Pictorial History of the University of Iowa*. Litterer's work is in the collection of the Chinese Consul in Chicago.

Chamber of Curiosities is an ongoing project exploring the spaces and displays of personal and public collections. It is an investigation of how people dominate and represent nature, especially animals, through their need to collect.
16" x 16" to 16" x 20" archival digital prints jenlit@hotmail.com

COLLEEN PLUMB (b. 1970, Chicago, Ill.) earned a BFA in visual communication from Northern Illinois University and an MFA in photography from Columbia College Chicago, where she teaches part-time. Her work is in the permanent collection and in the Midwest Photographers Project of the Museum of Contemporary Photography, and in the collections of the CITY 2000 project in Chicago and the Beijing Natural Cultural Center in China. Plumb's exhibitions include the Catherine Edelman Gallery, Renaissance Society, and Zolla/Lieberman Gallery, in Chicago, the U.S. Botanic Garden in Washington, D.C., and the SPE Regional Conference Exhibit in Fairfax, Va. She was awarded an Albert P. Weisman Memorial Scholarship and a Stuart Baum Grant. Her work has been published in *SHOTS* magazine 2005 portfolio issue.

My photographs investigate the relationship humans have with animals, how we coexist with the natural world, and the disappearance of nature within the urban space. Animals can be a link for humans to a deeper world of instinct and rawness, far from the fast pace of contemporary life. They appear as icons in campaigns representing a certain ideal, as pets or companions for novelty, sport, and work, and, of course, animals are used for food. Wild animals in a city can make themselves practically invisible; often their only evidence is revealed to us in a momentary glimpse or in finding their remains. I explore simulation, consumption, destruction, and reconstruction of the natural world.
19" x 19" chromogenic prints www.colleenplumb.com

SUZY POLING (b. 1975, Riverview, Mich.) received a BA in photography from Columbia College Chicago, where she was awarded the Albert P. Weisman Memorial Scholarship. Poling works as a photography instructor and freelance photographer. Her photographs have been shown at the Chicago Cultural Center, Carrie Secrist Gallery, and the Evanston Art Center, and in exhibits and magazines in Baltimore, Chicago, New York, Oakland, San Francisco, and London, England.

Themed Escape concerns the complexities and ambiguity of escapism, fixed reality, and the psychological embodiment of a place; it depicts fantasy rental theme rooms designed for people who wish to escape their everyday lives. I research and photograph places that I find perplexing. Each photograph is treated as a staged scene, where I exaggerate the odd qualities of each fake environment, hoping to envelop the viewer with intense color, humor, and discomfort. The viewer is left with hyper-real, absurd, and transparent descriptions of contrived interior spaces.

20" x 24" chromogenic prints www.suzypoling.com

THOMAS TUKIENDORF (b. 1981, Bensenville, Ill.) received a BA in photography from Columbia College Chicago, where he was awarded the John Mulvany Scholarship. He is a commercial architectural photographer and an avid fly fisher. His photographs have been exhibited at the In-Transit Gallery in Chicago.

These photographs are about places where humans control the environment, especially regions in the process of conservation and habitat restoration. My specific area of study is in southwest Wisconsin, where cold, clean spring creeks are prolific—perfect conditions for trout habitats. Trout are not native to that area, but were introduced when Eastern Europeans settled there. Now those fish are as wild and as common as any indigenous species. Although human impact on the area is on the rise, extensive habitat work is being done on the streams, making them possibly even better trout fisheries than they were naturally. I frame photographs that question human control of the environment, in hopes that the viewer will question the practices that make such extensive habitat "restorations" necessary.

11" x 14" archival digital prints www.thomastphotography.com

NATURE is no. 5 in the *6x6 Series* of photography books.

The *6x6 Series* is published by
the Photography Department of Columbia College Chicago
at 600 South Michigan Avenue, Chicago, Illinois 60605.
www.colum.edu

Series Coordinators: Tammy Mercure (tmercure@colum.edu)
 Bob Thall (bthall@colum.edu)

Design by Colleen Plumb (www.colleenplumb.com)

Copyediting by Christine DiThomas

Printed in Iceland by Oddi Printing, Ltd.

We would like to thank the artists and Thorsteinn (Steini) Torfason at Oddi.

ISBN 0-929911-15-6

Cover photograph: Colleen Plumb, *Rubens' Dogs*
Frontispiece: Gideon Barnett